# How to Make an American Mass Shooter: A Primer

# HOW TO MAKE AN AMERICAN MASS SHOOTER:
## A PRIMER

## DENISE MILLER

Q AN IMPRINT OF QUERENCIA PRESS – CHICAGO IL

Q AN IMPRINT OF QUERENCIA PRESS

© Copyright 2024
**Denise Miller**
**Interior Art: Emily Perkovich**

**All Rights Reserved**

No reproduction, copy or transmission of this publication may be made without written permission.
No paragraph of this publication may be reproduced, copied or transmitted save with the written permission of the author.

Any person who commits any unauthorized act in relation to this publication may be liable to criminal prosecution and civil claims for damages.

ISBN 978 1 963943 19 1

www.querenciapress.com

First Published in 2024

**Querencia Press**
**Chicago IL**
Printed & Bound in the United States of America

# CONTENTS

Introduction: An American Voice Addresses the Walls of Jericho .................................

Without Signaling ..................................
Without Wyaning ..................................
Without Absorbing ................................
Without Thinking .................................
Without Acknowledgment ........................
Without Loving ...................................
Without Huxanding ...............................
Without Falling ..................................
Without Feeling ..................................
Without Regretting ...............................
Without Being ....................................

# CONTENTS

Introduction: An American Values Education in the Wake of Charleston ................................................................. 9

Without Signaling ................................................................. 18
Without Weeping ................................................................. 19
Without Connecting ............................................................. 20
Without Thinking ................................................................. 22
Without Acknowledging ....................................................... 23
Without Loving .................................................................... 24
Without Humanizing ............................................................ 26
Without Failing .................................................................... 27
Without Fearing ................................................................... 28
Without Regretting .............................................................. 30
Without Losing .................................................................... 31

| | |
|---|---|
| Without Questioning | 32 |
| Without Pseudonyming | 34 |
| Without Worrying | 35 |
| Without Reckoning | 36 |
| Without Starving | 38 |
| Without Justifying | 39 |
| Without Restraining | 40 |
| Without Maligning | 42 |
| Without Revealing | 43 |
| Without Admitting | 44 |
| Without Corroborating | 46 |
| Without Criminalizing | 47 |
| Excerpts from "How They Got Their Guns" | 48 |
| | |
| Acknowledgments | 56 |

# INTRODUCTION:

## AN AMERICAN VALUES EDUCATION IN THE WAKE OF CHARLESTON

*"...it is not permissible that the authors of devastation should also be innocent. It is the innocence which constitutes the crime."* —James Baldwin, The Fire Next Time

It is important for me to be able to write this today. In the wake of this horrific crime in Charleston, to keep the families of these murdered in our hearts and minds, please take this space for a moment of silence.

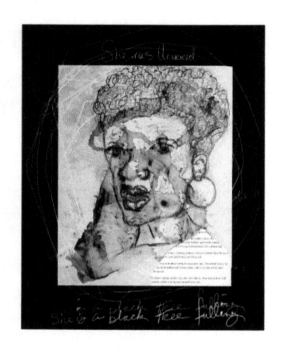

*Mixed media art by Denise Miller in direct response to violence against black and brown bodies. Tanisha Anderson was killed by Cleveland police on November 13, 2014.*

Now, however, it is time to speak because it is equally important to hold all those accountable who would paint this 21-year-old man, this product of a deeply and historically violent and racist society, as a "deranged individual." Doing so allows any person in this country — including the racist citizen and the citizen who refuses to believe that racism still exists in and is practiced by the sane minds of those living here — to refuse to see this deeply embedded racism as the thread that wove the fabric of this country. It also allows them to refuse to understand that racism is a learned behavior based on an American Values curriculum written by some of our so-called greatest thinkers and founding fathers. It is an historic curriculum implemented by local, state and federal governments, religious leaders, organizations, and by parents and other caregivers at dinner time around the family table. It has been, and still is, taught by the sane, and our citizens have been, and clearly still are, tested on it over and over again in this country's lifetime. We then cannot call this 21-year-old "deranged" or justify his behavior by naming his act an act of mental illness.

He is, unfortunately, a product of an education system — both public and homeschool — that did and is continuing to do its job immaculately. It is a system whose pupils, faculty, staff and administration must be held accountable but won't be if we put him and his actions in a box and set them aside as an anomaly or make them a kind of innocent as we do when we label someone mentally ill. When our past presidents, government officials, religious leaders and founding fathers shared his sentiments, we did not label them "deranged". We now in fact label them a product of their time so that we can excuse the fact that they created this violent and racist system with the same "brilliant" minds that they created some of our most revered documents and policies. The truth is, that they held slaves and talked freedom. They allow/ed black people to be lynched and killed in other horrific ways and, at the same time, talked peace. They allow/ed segregation and gentrification while they talk/ed the American Dream. This 21-year-old has been under their tutelage and so has his father, mother, grandfather, grandmother and so on. He has learned deeply and well.

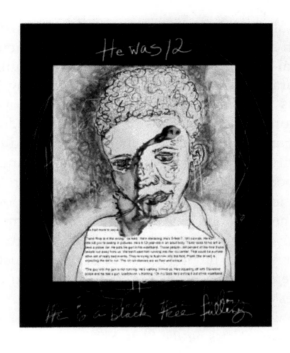

*Tamir Rice was killed by Cleveland police on November 22, 2014. Art by Denise Miller.*

Refusal, then, to see this 21-year-old's horrifically violent action as the result of an American Values curriculum is refusal to look at the curriculum itself, beginning with our Declaration of Independence and continuing through the words that leave the mouths of our governors and senators, police officers and so-called friends, the words that get tossed around teachers lounges and boardrooms and city streets, around courtrooms and dinner tables and Facebook and Twitter. All of these words are all a part of a curriculum that may have resulted in the following end of semester or end of year coursework by American pupil-citizens: the science fair projects manifested in the lynching and flaying of thousands of black men and women, and the postcards of their charred and bloated bodies that served as correspondence course materials that were inspired by textbooks such as Thomas Jefferson's *Notes on the State of Virginia* and have birthed such dissertations as the study of Eugenics and anthropological studies such as segregation which have created such practical applications as a 21-year-old getting and loading a gun, entering a church, seeking out and

sitting by its minister (a state senator), listening to the service for 40 minutes, allegedly making this statement: "I have to do it...You rape our women and are taking over our country. You have to go," and then opening fire, leaving 6 women and 3 men murdered.

The results of the test, you wonder? Did he pass? According to the curriculum he studied, he solved 9, but I am not sure just how many problems this American Values curriculum identified for him to solve. What is clear is that his words are only the echo of a speech taught, learned and repeated in the same faithful and patriotic manner as the Star Spangled Banner or the Pledge of Allegiance. For any of us to deny this would be to make him and this country innocent while giving up our own to find all of our fingerprints on the bullets loaded in the gun of the 21-year-old pupil of the American Values curriculum.

— Denise Miller

*Originally published in Praxis*

# THE MASS SHOOTER

**DECEMBER 14, 2012**

## GUNS, GUNS, GUNS!

REDACTED age 20, killed his gun-enthusiast mother REDACTED with a gun that was legally obtained by her. The gunman then proceeded to Sandy Hook Elementary School, where he shot and killed 26 people, most of whom were children under the age of 8, using a Bushmaster XM-15 rifle and a .22-caliber Savage Mark II rifle.

Sources report that before the shooting his mother often took her sons to shooting ranges to practice with the family's extensive collection of weapons.

continued on page 12

# WITHOUT SIGNALING

Birth a being with one Y
chromosome — bend the X
in them to embrace the binary.
Bind them — in blue, both denim
and bruises. Tell them — "man
up" before they ever stand.

# WITHOUT WEEPING

Teach their hands to hunt for
the tug of a trigger in the toy
chest — make sure they muddy
their hunting vest — let them
rest only after drawing blood
       — not after bleeding.

# WITHOUT CONNECTING

Teach them — the god-whittled white
of Adam's flesh and cartilage, split then fitted
to make Eve, is the only rib divine enough
not to divide by bullet, or table knife, or teeth,
or tongue — teach them their young are the only
ones worth keeping whole, breathing.

**JUNE 20, 2012** | continued from front

# 9 DEAD IN CHARLESTON HATE CRIME

...the alleged Manifesto of REDACTED age 21, was found on a website registered Feb. 9, only after the Nazi enthusiast entered the historically black Emanuel A.M.E. Church during Wednesday night's prayer meeting where he then murdered nine, including the Rev. Clementa C. Pickney, pastor & state senator. Friends of the shooter state that his plans were alluded to following the murder of the Florida teen, Trayvon Martin, perpetrated by neighborhood watch volunteer, George Zimmerman.

Though these same friends allege the website is most likely run by REDACTED not yet clear who wrote the Manifesto. The website details an intense fixation on black-on-white crime as well as other neo-Nazi rhetoric, including the praise of segregation, and defamtory language towards the black community.

The F.B.I. along with the Charleston Police Department have issued a statement that they are taking steps to verify the authenticity of the postings.

# WITHOUT THINKING

Bleach their vision so all
they see is teeth white skin—
ordain every other color, sin.
Begin when infant skulls are still
soft enough to bend. Make sure
there is no mending wall.

# WITHOUT ACKNOWLEDGING

Teach them, that a gun in the hand
is worth two bodies in the grave: First—
their sibling, shot accidentally, in the stomach
at playtime. Later—their lover's co-worker,
caught in the crossfire of their "if I can't
have her" bullet-riddled display of affection.

# WITHOUT LOVING

Tattoo XY on the eyelids and cheeks
of the one whose body birthed them—
make your fists the kiss they see you
mark morning and evening before
breaking bones and leaving, mirror
her inferior—damage domesticity.

# lithium_love

Male
26 years old
OREGON
United States

last login: 9/30/2019

**"How many girlfriends have you had?"**

**lithium_love:** 0. Never had anyone…I've never been with anyone, no woman nor man (nor dog or animal or any other).

**Anonymous:** must be saving yourself for someone special

**lithium_love:** Involuntarily so.

# WITHOUT HUMANIZING

Give them something to put in their crosshairs —
a tin can atop a fallen log, a stray cat cutting
through grass, a baby robin — their belly not
yet rust colored. Later, let them site their own
targets — a student standing in a hallway, a black
man in a church pew, a baby in its parents' arms.

# WITHOUT FAILING

Convince them they must draw breath
from the muzzle of Smith or Wesson —
Ensure they learn the lesson: breathe in slowly
while you identify your target beyond any doubt. Exhale,
squeeze the trigger before they've
had a chance to run — a chance to shout.

# WITHOUT FEARING

Teach them that their maleness or whiteness
or both will be bent around their bodies tighter
than armor — will shield them from laws that
should lay visible their lawlessness. Although
they've transgressed, their principles, parents,
police will protect, so we are none the wiser.

# THE MASS SHOOTER

OCTOBER 2, 2015

## "YOU'RE GOING TO SEE GOD IN ABOUT ONE SECOND"

Southern California native [REDACTED] was said to have been withdrawn child, unless engaged in talking of his hobby: collecting guns.

Two years after his move to Oregon [REDACTED] 26, murdered 9 students, wounding several others, in a writing class he was enrolled in at Umpqua Community College.

Investigators state he left a typewritten manifesto as well as an online footprint detailing his increasing interest in high-profile shootings & a bitterness with his "involuntary" loneliness, and was said to ask victims if they were Christian,

continued on page 3

# WITHOUT REGRETTING

Name them hero — a white knight in a too
black, too brown, too female, too immigrant
world. Make them believe they are Arthur
and label the sword pulled from that stone
the Ruger AR-15 whose bullet will be
fished from the flesh of their first kill —

# WITHOUT LOSING

Teach them to eliminate failure
by eliminating the origin of the no—
the girlfriend or wife—estranged or
restraining order—the boss or the boot
camp—let go or disciplined will all
disappear with the snap of a trigger finger.

# WITHOUT QUESTIONING

Tell them — live in a land that has more guns
than people. If possible, publicly carry, because
concealing won't call attention to the right they
have to wear their fear near their fist. Should some
one walk in their direction — the law says they've
got the right to stand their ground without question.

### AP - Inbox – Wed 5:00 AM, August 2019

**from:** Adelia Johnson
**to:** The Associated Press
**subject:** Dayton OH Shooter

-page 6/7-

My ex-boyfriend was a mass murderer. My ex-boyfriend was a mass murderer. I still don't know how to wrap my head around that. That man who was so sweet to me and told me he loved me was a mass murderer. I kissed a mass murderer. I thought I had decent judgement in character, but now I feel like my entire psyche needs to be scooped out and reevaluated under a microscope...

...

I also know that him getting shot is exactly what he wanted. He would have been the first one to tell you that he hated himself. He told me that twice he held a gun in his mouth ready to pull the trigger. He knew that he shouldn't have been allowed to own a gun, even though he loved guns. He believed as I believe that people with mental illnesses shouldn't be allowed to own guns because of people like him, people that turn into monsters.

# WITHOUT PSEUDONYMING

Teach them to write everything
that is wrong with their lives as
someone else's fault—if they
are loveless, let them take up
arms to make the world one
more woman less—

# WITHOUT WORRYING

Teach them not to love at a distance,
laissez-faire should never venture into
their vocabulary. Tell them, ignore the ex —
that begins any relationship explanation.
Assure them, the merchants will never ask
their mental state or evaluate their evaluation.

# WITHOUT RECKONING

Teach them how to pen their manifesto —
preferably in ink, but blood will also mark
the mythology that makes them lone wolf —
wilderness walking and wielding Manifest
Destiny. Teach them how to missionary metal
or lead so that they can demonize the dead.

**NOVEMBER 6, 2017**

continued from front

## U.S. AIRFORCE FAILS TO ENTER DOMESTIC VIOLENCE COURT-MARTIAL INTO FEDERAL DATABASE

...the report detailing REDACTED assault on his wife and toddler would have blocked the gunman from buying a rifle had it been appropriately filed. Law enforcement believes the attack may have been provoked following estrangement from his wife's family following the incident where he cracked the child's skull, as his mother-in-law was a member of the First Baptist Church he targeted. Freeman Martin, a Texas Department of Public Safety spokesperson made a statement saying they were aware of threatening texts sent to the in-laws and that authorities do not, at this time, believe the shooting to be racially or religiously motivated.

# WITHOUT STARVING

Feed them equal parts apple pie
and aggression, and when they've
formed an appetite, seed their obsession —
plow up any empathy that lay fallow,
hollow then furrow their soul. Let
them fertilize with their own delusions.

# WITHOUT JUSTIFYING

Buy them bullets and a bible for their birthday —
new lead but Old Testament. There is no
substitute for that "Vengeance is mine" kind
of tutelage — no stronger script to be used
to shapeshift women into wanton and wicked,
or center sin in the souls of the dark-skinned.

# WITHOUT RESTRAINING

Teach them first to fly their anger under the radar —
a few broken bottles scattered across a parking
lot — buckshot battering the back window of an
old car, junked just east of town — a slur sprayed
on a bright blue aluminum garage door down
the street. It will all serve as a kind of a teeth cutting.

## Could Odessa shooting have been prevented?

On Feb 7th, 2011 Amarillo TX police responded to a call made by the visibly distressed mother of REDACTED following an incident where he refused to take his mental-health meds. The lapse in medication resulted in conspiracy delusions and threats on his own as well as police lives. At the home police found a machete under his bed, an underground shelter, & a recording of the son with the sentiment, "911 will bow down before me."

Though police shared evidence & floor plans of the property with Amarillo's SWAT team, no further action was taken.

Last month, as police feared 8 years ago, REDACTED engaged police in a violent shooting rampage, killing seven and injuring 25 resulting in the shooter's own death, despite a previous failed background check for the AR-15 style weapon used in the attack and multiple police run-ins throughout the years.

At this time only 17 states & the District of Columbia have active red-flag laws. Texas is not one of them.

# WITHOUT MALIGNING

Brand them good ole boys, buy
them boots and baseball hats,
footballs and bats and bullets
to fill their backpacks, and tiki
torches and polo shirts, American
flags and guns — of course guns.

# WITHOUT REVEALING

Make misdirection — make sure in the wake
of their actions, society spends more time on mental
illness and misinformed gun sellers than their hate.
Push public perspective toward protecting parchment
instead of people. Paint them as patriots — instead
of what they are — pillagers of skin and blood and bone.

# WITHOUT ADMITTING

Teach them to tease their target — tell them to
wear anger like a WWII land mine laying in
the grass of a 2019 German forest. Tell them to tease
at terrorizing — carve a Swastika in a school desk
in sophomore study hall, toss a torn sheet of paper
with a list of Senior's names. Smile, sometimes.

# THE MASS SHOOTER

OCTOBER 2, 2017

## HOTEL ARSENAL

Vegas police state at least 23 firearms, including a handgun, were found in the hotel suite of REDACTED.

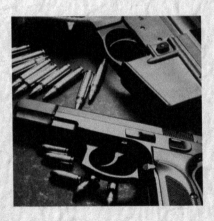

One anonymous official states there were as many as 20 rifles and hundreds of rounds of ammunition with 2 of the rifles scoped on tripods.

Sheriff Lombardo reported that REDACTED fired through his hotel room door at security on the scene injuring one guard. Lombardo additionally states more weapons (19 firearms) were found at the shooter's home in Mesquite...

continued on page 20

# WITHOUT CORROBORATING

Distort their read of reality from birth—
if they come out feet first, tell them it tells
them they should always lead. Or if before
toes and soles, their crown, crowns heir—
make them believe they're make believe
is enough to justify what's in their crosshairs.

# WITHOUT CRIMINALIZING

Teach them
to stockpile
steel, iron, Kevlar.
Teach them
to buy their
guns legally.

# EXCERPTS FROM "HOW THEY GOT THEIR GUNS" BY LARRY BUCHANAN, JOSH KELLER, RICHARD A. OPPEL JR. AND DANIEL VICTOR NEW YORK TIMES UPDATED FEB. 16, 2018

* FEB. 14, 2018 – Seventeen people were killed when xxxx, opened fire at his former high school in Parkland, Fla., with a Smith & Wesson M&P semiautomatic rifle. ON FEBRUARY 2017 xxxx legally bought the AR-15-style rifle at Sunrise Tactical Supply in Florida.

* NOV. 5, 2017 – A gunman identified as xxxx 26, opened fire at a Sunday service in a rural Texas church, killing at least 26 people. The authorities said Mr. Kelley used a Ruger AR-15 variant, a knockoff of the standard service rifle carried by the American military. Mr. Kelley purchased two firearms — one in 2016 and one in 2017 — from two Academy Sports & Outdoors stores in San Antonio. He passed a federal background check in both cases, according to a statement released by the store.

* OCT. 1, 2017 – Fifty-eight people were killed and more than 500 were wounded when xxxx, from a perch high in a hotel, opened

fire onto a crowd of concertgoers at an outdoor music festival in Las Vegas. Authorities recovered an arsenal of weapons — at least 23 from his hotel room — including AR-15-style rifles. Mr. Paddock legally purchased 33 firearms from Oct. 2016 to Sept. 2017, Ms. Snyder said. Most of those guns were rifles. Such purchases do not prompt reports to the bureau because there is no federal law requiring a seller to alert the bureau when a person buys multiple rifles.

* JUNE 12, 2016 – Forty-nine people were killed and 53 wounded when xxxx opened fire at a crowded gay nightclub in Orlando, Fla. He used two guns: a Sig Sauer AR-15-style assault rifle and a Glock handgun. Mr. Mateen legally bought two guns, a federal official said. "He is not a prohibited person, so he can legally walk into a gun dealership and acquire and purchase firearms," said Trevor Velinor, an agent at the Bureau of Alcohol, Tobacco, Firearms and Explosives.

* DEC. 2, 2015 – Syed Rizwan Farook and Tashfeen Malik, husband and wife, killed 14 people at a holiday office party in San Bernardino, Calif. Four guns were recovered: a Smith & Wesson M&P assault rifle, a DPMS Panther Arms assault rifle, a Smith & Wesson handgun and a Llama handgun. BETWEEN 2007 AND

2012 **xxxx** bought the two handguns legally in California, federal officials said. The guns were purchased at Annie's Get Your Gun, a gun store in Corona, Calif., The Los Angeles Times

* OCT. 1, 2015 – **xxxx** 26, killed nine people at Umpqua Community College in Oregon, where he was a student. He was armed with six guns, including a Glock pistol, a Smith & Wesson pistol, a Taurus pistol and a Del-Ton assault rifle, according to The Associated Press. BEFORE SHOOTING In all, Mr. Harper-Mercer owned 14 firearms, all of which were bought legally through a federally licensed firearms dealer, a federal official said. Some were bought by Mr. Harper-Mercer, and some by members of his family.

* JULY 23, 2015 – Using a .40-caliber semiautomatic pistol bought from a pawnshop, **xxxx** Houser killed two people and wounded nine others at a movie theater in Lafayette, La. 2014 Mr. Houser bought the weapon in Alabama. Officials said it had been purchased legally, though he had been denied a concealed weapons permit earlier, and despite concerns among family members that he was violent and mentally ill.

* JUNE 17, 2015 – **xxxx** 21, killed nine people with a .45-caliber Glock pistol at a historic black church in Charleston, S.C. APRIL

2015 He purchased a gun from a store in West Columbia, S.C. Mr. Roof should have been barred from buying a gun because he had admitted to possessing drugs, but the F.B.I. examiner conducting the required background check failed to obtain the police report from the February incident.

* OCT. 24, 2014 – xxxx 15, used his father's Beretta pistol to shoot and kill four students in his high school's cafeteria in Marysville, Wash. 2013 xxxx applied to buy the Beretta from a gun shop on the Indian reservation where he lived with xxxx background check failed to come up with the protection order because it was never entered into the system.

* APRIL 2, 2014 – Specialist xxxx opened fire at Fort Hood with a Smith & Wesson semiautomatic pistol, killing three people and wounding 16 others. MARCH 1, 2014 xxxx legally bought his gun.

* SEPT. 16, 2013 – xxxx, 34, used a Remington shotgun to kill 12 people at the Washington Navy Yard. SEPT. 2013 He was stopped from buying an assault rifle at a Virginia

* gun store but was allowed to buy a shotgun. He passed local and state background checks.

* AUG. 5, 2012 – xxxx 40, killed six people with a Springfield

Armory semiautomatic handgun when he opened fire in the lobby of a Sikh temple in Oak Creek, Wis., as congregants arrived for Sunday services. JULY 2012 He bought the firearm legally at a gun shop outside Milwaukee. He passed a background check and paid $650 in cash.

* JULY 20, 2012 – James E. Holmes, 24, killed 12 people and wounded 70 at a theater in Aurora, Colo., using a Smith & Wesson semiautomatic rifle, a Remington shotgun and a Glock .40- caliber semiautomatic pistol. MAY 2012 In the 60 days before the shooting, he bought four guns legally at local gun shops. Seeing a psychiatrist, even for a serious mental illness, would not disqualify him from buying a gun.

* APRIL 2, 2012 – xxxx 43, opened fire with a semiautomatic handgun at a small religious college in Oakland, Calif., where he had been a student. He killed seven people. EARLY 2012 xxxx legally bought the handgun at a gun store in Castro Valley, Calif., passing a federal background check.

* JAN. 8, 2011 – xxxx 22, killed six people with a Glock handgun in a supermarket parking lot in Tucson, Ariz., at an event for Gabrielle Giffords, who was a Democratic representative from Arizona. NOV. 30, 2010 He passed a background check and

bought the handgun at a store in Tucson, Ariz.

* NOV. 5, 2009 – xxxx 39, an Army psychiatrist facing deployment to Afghanistan, opened fire inside a medical processing building at Fort Hood in central Texas, killing 13 people and wounding 43 others. He was armed with an FN Herstal pistol. JULY 31, 2009 xxxx bought the pistol legally at a popular weapons store in Killeen, Tex., paying more than $1,100.

* APRIL 3, 2009 – xxxx 41, fired at least 98 shots from two handguns, a Beretta 92 FS 9- millimeter pistol and a Beretta PX4 Storm pistol, inside a civic association in Binghamton, N.Y., where he had taken an English class. He killed 13 former classmates and association employees.

* MARCH 2008 – xxxx bought the first gun, the Beretta 92, at a store in Johnson City, N.Y. He passed a background check. MARCH 2009 xxxx bought the second gun from the same store, but his background check was not approved immediately. He received the gun under a federal rule that allows a gun to be sold if the background check system does not return a decision in three business days.

# ACKNOWLEDGMENTS

The following articles were used as inspiration for the visual prints in this books —

* "How They Got Their Guns" By LARRY BUCHANAN, JOSH KELLER, RICHARD A. OPPEL JR. and DANIEL VICTOR *The New York Times — Feb. 16, 2018*

* "Dylann Roof Photos and a Manifesto Are Posted on Website" By FRANCES ROBLES *The New York Times — June 20, 2015*

* "Oregon Killer Described as Man of Few Words, Except on Topic of Guns" By JACK HEALY and IAN LOVETT *The New York Times — Oct. 2, 2015*

* "Dayton shooter had an obsession with violence and mass shootings, police say" By PAUL P. MURPHY, KONSTANTIN TOROPIN, DREW GRIFFIN, SCOTT BRONSTEIN and ERIC LEVENSON *CNN – Aug. 7, 2019*

* "Shooter's ex-girlfriend: The dilemma of when to intervene" by JOHN SEWER *Alternative Press – Aug. 9, 2019*

* "Air Force Error Allowed Texas Gunman to Buy Weapons" by DAVID MONTGOMERY, RICHARD A. OPPEL JR. and JOSE A. DEL REAL *The New York Times – Nov. 6, 2017*

* "Police feared Odessa shooter was planning attack" by CURT DEVINE *CNN – Sept. 29, 2019*

* "Multiple Weapons Found in Las Vegas Gunman's Hotel Room" by THE NEW YORK TIMES *The New York Times – Oct. 2, 2017*

Printed in the USA
CPSIA information can be obtained
at www.ICGtesting.com
JSHW052041270824
68823JS00006B/43